Beyond the Bounds of Time

Daydreaming of Forever

Poetry Collection

Ronald J Chapman

Beyond the Bounds of Time

"Have you ever been lucky enough to figure out where your dreams come from? I have. I've written many poems about a place that I have only been to in my dreams. This beautiful place is called Korea.[1]"
- Ronald J Chapman 2013

"Lots of guys dream about beautiful women. I dream about a place where beautiful women live."
- Ronald J Chapman 2015

"'So close yet so far.
I can still wait to return home. After all. I lived here a thousand years ago. It's my destiny."
- Ronald J Chapman July 19, 2015

"The place I will never be able to visit in this lifetime. (Korea) But a place I will love forever. The great distance, the distance of mountains and oceans between us is like touching a dream a star in the sky. Too far away."
- Ronald J Chapman February 9, 2016

"Because of you Korea,
I discovered after four decades of heartache that I could dream again, since that June day, in the year of the dragon, 2012. I've written more than 600 dreams about a beautiful place I pray every day that God! Sends me a miracle so that I can touch your earth under Heaven's skies after such a long time.
Thank you, Korea."
Ronald J Chapman September 3, 2016

TABLE OF CONTENTS

COPYRIGHT INFORMATION	iii
ADDITIONAL INFORMATION	iv
ACKNOWLEDGMENTS	v
DEDICATION	vi
All I Have Left	1
Always Looking	2
Beautiful Dream	3
Beauty, With No Name	4
Beyond the Bounds of Time	6
Clouds	8
Cloudy Days	9
Cup of Love	10
Dancing	11
Delightful Hope	12
Despair	14
Empty Boat	16
Falling Rain	17
Feeling Scared and Alone	18
For My Love, Summer	20
Ghost	21
Ghostly Mist	22
Heaven's Tears	23
Homeless	25
Impossible Place and Time	26
In Dreams	27
Joseon	28
Lifelong Quest	30
Looking for You	32
Love You Always	33

Beyond the Bounds of Time

Magical Voice	35
Make a Wish	37
Memory Misplaced	39
Memories Unraveling	40
Misty Rain	41
Moonlight	43
My Dream	44
New Day's Breeze	46
North	47
On Rainy Days	48
Our Beautiful Night Love	49
Our Bright Golden Love	51
Painted Sunrise	53
Passing Souls	55
Rainy Days	56
Red Tulip	57
Returning to Me	58
Searching	59
Take a Chance	60
Temptation Bounds Me	61
The Morning Calls to Me	62
Treasure the Moment	63
Unforgettable	64
Waiting for You Love	65
Watching a Miracle	67
What Can I Do?	68
End Notes	70

Beyond the Bounds of Time

COPYRIGHT INFORMATION

Copyright © 2017 Ronald J Chapman
All rights reserved. No part of this publication may be reproduced, distributed, or transmitted in any form or by any means, including photocopying, recording, or other electronic or mechanical methods, without the prior written permission of the publisher, except in the case of brief quotations embodied in critical reviews and certain other noncommercial uses permitted by copyright law. For permission requests, please write, Ronald J Chapman at ronchap3@gmail.com
This is a work of fiction. Names, characters, businesses, places, events and incidents are either the products of the author's imagination or used in a fictitious manner. Any resemblance to actual persons, living or dead, or actual events is purely coincidental.

Cover photo by Ronald J Chapman

CreateSpace ISBN.
ISBN-13: 978-1537735023
ISBN-10: 1537735020
Printed in the USA

Published February 14, 2017
Order online: Available from Amazon.com

Facebook Poet Ron
https://www.facebook.com/ka2hzo
Scan this with a smartphone app that reads QR Codes.

Ronald J Chapman

Beyond the Bounds of Time

ADDITIONAL INFORMATION

Cover Photo:
The cover photograph of the starry night sky was captured August 27, 2016, shows the great Mars and Saturn conjunction of 2016.

QR Codes:
Included with some of the poems are QR Codes ("Quick Response" Codes). These are the black and white squares located below the poems.
Scan these codes with a smartphone app that reads QR Codes.
After scanning these codes. A video that is relevant to the written piece will appear on the smartphone.
All of the YouTube video links were accessed and active on February 7, 2017

End Notes:
Notes that explain the terms and phrases used are at the end of the book in this section (End Notes).

ACKNOWLEDGMENTS

I began to paint with words—write poetry--after recovering from surgery. My physicians suggested that I should exercise both my mind and body. I then took up the hobbies of walking, photography, and writing.
I wish to thank my friends and family for their encouragement and support.

I appreciate you the reader for buying and taking the time to read my book "Beyond the Bounds of Time." I sincerely hope you enjoy reading my poetry collection inspired by a miracle.

- Ronald J Chapman

Beyond the Bounds of Time

DEDICATION

To all the storytellers
who share their dream diaries with the rest of us.

Beyond the Bounds of Time

ALL I HAVE LEFT

How many times,
Will you return to me,
In my remarkable dreams?

You taking my hand,
Guiding me to a magical land,
To a time of kings and princesses.

Chasing my fears away,
Remembering your tears,
Longing for the taste of your lips,

I can't forget the black nights,
We held each other so tight,
Your glow was bright as a new dawn.

Am I foolish waiting for you each lonely night?
How many more nights will you visit me in dreams?
So I can wipe away the tears.

My dreams are all I have left from you.

Lyn - Back In Time (The Moon That Embraces The Sun OST)
https://youtu.be/qXi2hhfXn6w
Scan this with a smartphone app that reads QR Codes.

Ronald J Chapman

Beyond the Bounds of Time

ALWAYS LOOKING

I'm looking at you in my dreams,
Are you secretly dreaming of me too?

In this vast world,
I'm still seeking to find you;

To hold you in my arms, my bride,
Walking side by side,
Holding your hand, looking at the stars in the sky,

To love you more each day,
Dreams are not intimate enough,

It seems this mad world,
Wants to keep our hearts apart,

If it should take one hundred lifetimes or ten thousand centuries,

To find you,

I will always look for you, my love.

Lea Michele - TO FIND YOU [HQ] - Lyric Video
https://youtu.be/XfZfnkFnLKY
Scan this with a smartphone app that reads QR Codes.

Ronald J Chapman

Beyond the Bounds of Time

BEAUTIFUL DREAM

Every night in my lonely dreams,
You come to me from a far away place, (Korea)
And a distant time, (The time of Joseon2.)

You are my destiny,
My lost love,
The Heavens took away on that cold June day.

But in early July every year,
A starry night's dream comes to me and sings of love,
Meant to be, as a great gift from God,
You are my love song, my destiny,

We spend a night, a dream of making impossible love,

You are my Angel,
I will love you forever and ever,

My beautiful dream,
You are my everything!

The Prince From Joseon fanfic trailer [KaiStal]
https://youtu.be/TJr-Shv7GT4
Scan this with a smartphone app that reads QR Codes.

Ronald J Chapman

Beyond the Bounds of Time

BEAUTY, WITH NO NAME

I've always known,
You are only but a dream,

You visited me every night.
Before I even knew your name.

Beauty, with no name,
Holding, Sharon's Rose,
With thorns,
Stabbing my heart with impossible memories,

Leaves me with nothing but pain,
A rose and my heart,
Makes me see a miracle,

So much beauty,
So many thorns,
So much pain,

I dream of touching you,
My Seoul every day.

Love and pain balance the scale with your beauty,

I turn out the lights,
My dreams of you brighten my days.

I know I will never touch you,
My heart beats with unimaginable pain,

I think of doing something crazy.

Flying on a silver winged Magpie,
I'm afraid my heart will burn to ashes,

To stop longing for you,
Today, I'm ready almost,
To take a chance,

Ronald J Chapman

Beyond the Bounds of Time

Flying into to your arms,
Or standing at Heaven's gates!

What should I do?

My sweet Seoul
https://youtu.be/IKpaFk3GhsI
Scan this with a smartphone app that reads QR Codes.

Ronald J Chapman

BEYOND THE BOUNDS OF TIME

Walking through a pine forest,
A fresh wind showing me the way,
Times past, so long ago.

Dreams beyond the bounds of time,
Guiding my way today,
Old friends so far away, so long ago.

Am I just dreaming?
Waking up together on a bright summer morning with my wife,
Talking about dreams,
As we walk holding hands to the edge of a rippling pond.
How many children will we have?

Kissing under a full moon on a warm summer night.
We were both, enjoying the magic,
These days and nights of dreams from another time,
Another place,
Guiding me, through my lonely days.

Am I only dreaming?
Waking up on a bright summer morning alone,
Looking for her in the bright daylight,

She has gone home, to a place,
Beyond the bounds of time,
Where I can only follow her, in my dreams.

Beyond the Bounds of Time

Dr. Jin ~ Now And Forever(eng/rom sub)
https://youtu.be/txzx5CT4Viw
Scan this with a smartphone app that reads QR Codes.

Beyond the Bounds of Time

CLOUDS

Today, I saw the most beautiful Far Eastern sky,
That chased my sorrows away,

Turning around all I see is you,
Your love knows no bounds,
An Angel flying among the clouds,

I'm afraid the clouds will scatter and fly away,

I see you in my eyes,
Your cotton clouds warming my Soul,

In my eyes, I only look to you my sunshine,

My Soul wishes to fly away with you,
Until the end of time,
My heart cries out, "I love you. Please don't go."

Your love is what I depend on,
To wash away the lonely yellow dust from my sky.

Holes in the Sky - M83 ft. HAIM (Lyrics)
https://youtu.be/3mP9nOtu3IU
Scan this with a smartphone app that reads QR Codes.

Ronald J Chapman

Beyond the Bounds of Time

CLOUDY DAYS

Even cloudy days are beautiful,
When I'm standing here, close to you.

While the cold rain is falling,
I see the bright sunshine,
Sparkling in your dark eyes,

Seeing cherry blossoms blooming all around you,

Even cloudy days are enjoyable,
When I'm holding you in my arms.

When I look at gray skies,
Finding the blue openings between the clouds,
I always know hope exists.

Hoping to see a flicker of memory,
Filled with sunshine of you and me,
Loving so deeply in another time.

My Rainy Days - The End?
https://youtu.be/eQAbNA4ZyRs
Scan this with a smartphone app that reads QR Codes.

Ronald J Chapman

Beyond the Bounds of Time

CUP OF LOVE

Fate sent me to you,
Meeting you under a cherry blossom tree,
Drinking down your warm, sweet cup of love,

Catching your honey tears, with my lips,
You become my blessedness,
You become my hope,

Your love tastes sweet, like cherry wine,
It fills my heart,
And takes away my sorrowful hunger,

Together with you forever,
Drinking from your,
Never empty cup of love, is my blissful dream.

Jang Na Ra - Walk In A Dreamy Road (애지아) (Dong Yi OST
https://youtu.be/3zG9e66Rs7s
Scan this with a smartphone app that reads QR Codes.

Ronald J Chapman

Beyond the Bounds of Time

DANCING

Thinking of love and you,
Remembering a beautiful time,
You and I dancing to a dreamy song,

We would dance until dawn,
Holding each other close,
Feeling the beating of our warm hearts,

Holding on tight through the night,
So close, our Souls become one,
Such passion, such never ending love,
Love as vast as the Universe and time itself,

An impossible connection to you,
An impossible time we are together,
An Impossible place thousands of years in the past,

Out of all the possibilities,
Knowing I have discovered the miracle of you,
The miracle of you and me dancing together in a dream,

Do you dream of me?
Do you know I exist in your distant future?

Meet Again–Korean Drama Time Travel/Reincarnation Theme
https://youtu.be/VZwn1FhSQ0E
Scan this with a smartphone app that reads QR Codes.

Ronald J Chapman

DELIGHTFUL HOPE

A long time ago,
At the beginning of fate's eastern path,
You and I touched in a dream,

On the sunrise of a new life,
You became a delightful Hope,
That opened my heart;

To a beautiful miracle,
To a wonderful new world,
To the past life and home, I mourn every day.

My dream,

But you still don't know who I am,
The only time I can touch you,
Is in my world of fantasies,

I truly don't know,
When I will be able to take that first step,
On fate's path, to find you in this life,

To kiss your hand and,
Hold your Soul forever in my arms,
You! The Love of my sweet dreams.

Lee Sang Gon (NOEL) _ My love is hurt
https://youtu.be/bsWw7XTVo3k
Scan this with a smartphone app that reads QR Codes.

Beyond the Bounds of Time

DESPAIR

I feel sorrowful,
Darkness makes me ill,
I feel miserable, depressed,
My heart is drenched in soju[3] tears.

Hunger rips at my foundations,
I feel tired,
Anger is dragging me down to the depths of misery,
I want to die!

Is it because of being alone for so long?
With the blue rays of despair, raining down on my Soul?
Or am I lost in a tale of Hwang Jini, adrift far from my home,
A foreigner missing his Seoul[4],
I don't know?

Kyung Mi, I miss you, my wife,
Kyung Mi I miss you, my love,
Kyung Mi I miss you my best friend,
I was getting better but then,
Thoughts of never seeing Kyung Mi broke my heart again,

I feel brokenhearted,
Cold nights chill the flesh on my empty hands,
I feel downcast,
An outcast, living far from home, missing his Seoul,
Feeling crushed my only purpose.

I feel miserable,
Death is doing its best to take my Soul,
I want this to end!

Is it because of being alone that I feel this way?
With the blue rays of despair, drenching my heart?
Am I lost in a story of Hwang Jini, adrift far from home and alone,
I don't know?

Kyung Mi missing my one true love,

Beyond the Bounds of Time

Kyung Mi missing your beauty,
Oh! God, Kyung Mi missing your kindness,
I was getting better but then memories of you,
Thoughts of never seeing Kyung Mi broke my heart again,

Oh! God! Take me back home.

49 Days ~ Tears Are Falling (eng/rom sub)
https://youtu.be/kX3qaC0-dX0
Scan this with a smartphone app that reads QR Codes.

Ronald J Chapman

Beyond the Bounds of Time

EMPTY BOAT

Across a great river,
My heart and my mind live,

In a dream my home country vaguely familiar,
Living in a cold, wet straw covered house,

An empty boat floating on the river,
Thinking of you,

Many times remembering our youth,
Many dreams of you and me floating in the river's mist,

Unable to forget you,
Unable to step into an empty boat without you,

Looking Far to the East,
Hoping my memory,
Will rise in your dreams someday too.

Song SoHee - Lost | 송소희 - 방황 [Immortal Songs 2]
https://youtu.be/ZJHvh3q6-jA
Scan this with a smartphone app that reads QR Codes.

Ronald J Chapman

FALLING RAIN

Falling, falling, rain.
Never ending rain,
Drowning flowers,

Drowning love,
Watering my sorrow,
Sorrow growing, like, crabgrass,

Helpless to stop the flood,

Alone,

Waiting for clear skies, and the sunshine.
Will love ever grow again?

[Temptation 유혹 OST]Tears Rain - Seo Young Eun (So sad!)
https://youtu.be/oI36dZDNQJs
Scan this with a smartphone app that reads QR Codes.

FEELING SCARED AND ALONE

I always remember your words,
Be happy, smile on rainy days and stormy nights,

It's late,
The sounds of the day have grown silent,
Heavy thunder,
Rain hitting the windows, trying to break in,

Late at night,
Dreams piercing my heart,
Feeling scared and alone,

Looking for reasons to remember you,
Surrounded by reflections of you in every rainy window,
You, who I fell in love with, in such a far away place,
Such a long time ago,

Distance and time,
The most painful of reasons remembering you,

Like rain on a dark night,
It never seems to end,
Until the bright blue skies of dawn come.

Like never ending love,
The more I fill my heart with visions of you,
The clearer my life becomes.

Hyorin - Because It's You
https://youtu.be/QlUCZtX37vg
Scan this with a smartphone app that reads QR Codes.

Beyond the Bounds of Time

FOR MY LOVE, SUMMER

I feel so young and happy sometimes,
When I see, the beauty reflected in you each day,
And when I see you, I see the sunshine,
I love you more than words can say...

You're so beautiful! These summer days are excellent! So warm,
Your, bright yellow color, it's beautiful!
Even, when your petals and life, fade into shadows.
I am absolutely in awe of you!

Your Soul is vibrant; your heart is young,
And my heart is warmed by your yellow sunshine,

I could go on, and on watching you grow 'til life was done,

This intense happiness your petals reflect,

Like a golden lily in sunlight,
And for you, Mother Nature,
Thank you for this warm summer,

A summer filled with sunshine and flowers.

Frozen "In Summer" Song
https://youtu.be/rnEB2F_v_cE
Scan this with a smartphone app that reads QR Codes.

Ronald J Chapman

Beyond the Bounds of Time

GHOST

Pine forest, cool wind,
Bamboo swaying in the sunshine,
Lonely sunbeams fly through the morning mist,
Sunshine kisses my cheek.

Mist filled with ghosts,
Left behind from the night,
Cold wind blows away the fog,
Only one ghost remains.

Watching a memory walk in daylight,
How strong the warm wind blows,
Until I am no longer cold,
Until your Soul touches my heart.

Suddenly my heart is filled with loving memories,
A warm spirit wraps me in her arms,

Unable to let go,
Of her kindness, her joy, her love...

Zia - The Day FMV (Empress Ki OST)
https://youtu.be/UJ2pu3EXi6s
Scan this with a smartphone app that reads QR Codes.

Ronald J Chapman

Beyond the Bounds of Time

GHOSTLY MIST

Another wishful night falls,
Gazing at the stars in Heaven,
It's you who is clear to me,

Always dreaming,
Dreaming of only you,
Dreaming of only you and me, you saving a lost Soul,

I'm calmed by the memories of you,
My yearning heart rises to your smile,
I carry your likeness always in my mind,

In the hushed night,
Shooting stars fly,
Beckoning me to fall asleep.

I wait for the pure moonlight,
To shine through my windows,
A ghostly mist surrounds me,

My heart misses a beat, A ghostly figure in the fog,
Time has come, to uncover my Soul,
It's you! You who saved my spirit, so very long ago...

Ben - Stay MV (Oh My Ghost OST)
https://youtu.be/_M6pODHiG8g
Scan this with a smartphone app that reads QR Codes.

HEAVEN'S TEARS

Standing on a mountain top alone,
Looking at the mid-August night sky,
Seeing Heaven crying tears,

Tears carrying memories of you back to me,
It's so hard to erase the memories,
We made together from my mind.

Each bright tear fills my heart with kind thoughts of you,
From our days past.

With you and me holding each other's Souls close,
We were always afraid to let go,
For if we did,
Our love would not last.

But, I'm still trying to hold on to you,
Should I feel guilty not letting you go?
Not letting anyone else's tears fill my heart?

How can I just let you go?
When I see falling stars each night, like Angels from Heaven,
Carrying messages from you,
Telling me not to let you go.

Beyond the Bounds of Time

[Eng/HD] Kim JunSu and Yoon GongJu - "Can You Hear Me"
https://youtu.be/I8R94A102a0
Scan this with a smartphone app that reads QR Codes.

Can You Hear Me "Tears of Heaven" Eng. Pop Version
https://youtu.be/blMTzBOj2eo
Scan this with a smartphone app that reads QR Codes.

Beyond the Bounds of Time

HOMELESS

In the darkness of the night,
Away from all street lights,
Some drifters walk past,

A cold wind is blowing,
Where are you going?
Please look at me!

Hopeless and desperate,
Hiding in the shadows,
Forgetting who I am.

Phil Collins Another Day in Paradise
https://youtu.be/MFnNMhTZ2AA
Scan this with a smartphone app that reads QR Codes.

Ronald J Chapman

Beyond the Bounds of Time

IMPOSSIBLE PLACE AND TIME

A pretty place,
A beautiful time,

A place where Sakura grows.
A time of peace,

You and I, embrace;

Feeling the warmth of dawn's new sunshine,
The touch of a fresh spring breeze,
Where each breath brings us even closer.

I'm standing here holding on tight,
Am I dreaming with my eyes open?

Take my hand,
Come with me.

Let's travel through the doorways of our dreams,
To an impossible place,
And live and love in an impossible time.

Be my dream forever and a day.

Kim So Jung - It's You (eng sub) (Queen In Hyun's Man OST)
https://youtu.be/GXJIl2eDGpY
Scan this with a smartphone app that reads QR Codes.

Ronald J Chapman

Beyond the Bounds of Time

IN DREAMS

Two Souls wandering through a wasteland of time,
Looking far into tomorrow,
Longing filled with sorrow,
It doesn't matter how far you are from me.

Alone,
Visiting each other in dreams,
Not knowing, our fantasies are real,
That you indeed exist in my world.

Centuries past,
Future years,
It doesn't matter,

Our longing Souls,
Will meet in Heaven someday,

Never alone again.

Hwajung OST Part.3 Dreaming Dream ENG Sub Super Junior
https://youtu.be/ETRqZSH2gkw
Scan this with a smartphone app that reads QR Codes.

Ronald J Chapman

Beyond the Bounds of Time

JOSEON

I don't know what to do?
How can I feel your earth below my feet again,
After a thousand years of being alone?
Without disobeying the wishes of my family?

How can I love you?

How can an old Soul travel to a young miracle?
How can I touch a re-born Seoul?

My only way to love you.

Is to show the world,

How beautiful you are,

How a Phoenix has risen,
From the ashes of war.

Is love worth taking the chance?
A chance of dying before I can ever return home,
My home of a thousand years, Joseon!

The home that I was cursed to remember forever,
An impossible love that I can never say goodbye to,
A Love that will last for eternity.

Beyond the Bounds of Time

[MV] Gummy(거미) Would you love me(사랑해주세요)
https://youtu.be/tniolHA5aDE
Scan this with a smartphone app that reads QR Codes.

Beyond the Bounds of Time

LIFELONG QUEST

You are my Angel,
A most brilliant star from the East,

Always shining, you brighten my days,
While hiding behind a blue sky,

You light up my dreams,
Like a bright sun, that warms my cold Soul,

You are my never-ending dream,
Searching for you is worth my lifetime,
And ten thousand more.

I won't give up,
Until I can hold you in my arms, my wife,
You are the never ending quest of my life,

Through these complicated times, you give me hope,
Through each lonely day and night,
Unknowingly, you are the star that guides me in my dreams,

Because of you, I want to live again,
To let go of these lonely days,
I want to love again,

Searching for a star from Heaven,
Is the only purpose I have left in my life,
Hoping, you will fall into my arms one day.

Beyond the Bounds of Time

ALi - CARRY ON FMV (Faith OST) ENGSUB
https://youtu.be/949mw-0VLoQ
Scan this with a smartphone app that reads QR Codes.

Beyond the Bounds of Time

LOOKING FOR YOU

The night comes,
Red sunset, orange clouds,
Bright lights are hanging from a black velvet curtain.

How can I enter your dreams?
A crescent moon,
Points to you.

Hoping to return to that June day,
That day that changed everything,
That day you took my heart and Soul,

A sleepless night, impossible to forget,
Sorrowful days spent,
Looking for you.

Was our meeting the work of fate?
Was our meeting meant to be?
Or, was our meeting only but a lonely man's dream?

The Master's Sun Julie Anne San Jose Right Where You Belong
https://youtu.be/PhkvKuYLZTg
Scan this with a smartphone app that reads QR Codes.

Ronald J Chapman

Beyond the Bounds of Time

LOVE YOU ALWAYS

In springtime,
I fell in love with a foxy lady.
She was like cherry blossoms floating in the breeze.

When spring flowers bloom,
Our love is bold,
Like white petals on a rose.

In the summertime,
Our love is warm — She tickles my fancy!
With nine tails like white feathers floating from head to toe.

When dawn is bright and blue,
Our love is playful — two people kissing in the sunshine.
If thunder rolls in, our love is brave,
A shelter from the drenching rain.

When autumn leaves fall, our love is golden and sweet,
Shining bright like a persimmon harvest at sunrise.

From the Mid-autumn Festival till the first dawn of the new year,
Our love will continue to shine.

For thousands of seasons past and future,
In this world without end,
We have always loved and will love always!

My only love, my Gumiho[5].

Beyond the Bounds of Time

Lee Sun Hee - Fox Rain MV (My Girlfriend Is A Gumiho OST)
https://youtu.be/q0aZAP08y6w
Scan this with a smartphone app that reads QR Codes.

Beyond the Bounds of Time

MAGICAL VOICE

My dear haegeum[6],
You sing so beautifully,

You sound like a dream to me,
You are so very magical!

I'm only telling the truth,
When I say, I love you.

You are an instrument created by a miracle!

How can I appreciate you more?
But to write these words about you,
And introduce you to the world,

The magical musician,
Tickles your strings,

And

Your two silk strings,
Tickle my ears with your eight voices,
The sounds of the Universe,
Gold, rock, thread, bamboo, gourd, soil, leather, and wood,

My dear haegeum,
You sing so beautifully.

*The haegeum is a traditional Korean string instrument.

Ronald J Chapman

Beyond the Bounds of Time

Sensation - Ccot-byel, Haegeum Player
https://youtu.be/aIYCyIxDUcE
Scan this with a smartphone app that reads QR Codes.

Beyond the Bounds of Time

MAKE A WISH

Here I am from a far off place,
Looking at your reflections in my dreams,

Looking at you through snowy cherry blossom trees,
Seeing your bright, happy face,
From a distant time and place,

Listening to you sing cheerful songs,
I see a smiling princess,

I miss you when I'm awake,
I wish for you every day,

My love for you will never end,

My only love,
Do you wish for me too?
Do you see me standing beside you?

I think of you every day,
That I am holding on tight to your hand,
I want to keep you close to my heart,

I think of you every day,
I will wish for you for eternity.

SNSD (Girls' Generation) - Tell Me Your Wish (Genie) MV
https://youtu.be/zhouXHI5Bec
Scan this with a smartphone app that reads QR Codes.

Beyond the Bounds of Time

MEMORY MISPLACED

Finding that memory,
A memory misplaced in space and time,
Only a memory that a cold winter wind can bring.

Is like finding a ring of diamonds and gold,
In a white veil of snow,
So breathtaking, sends chills down my spine.

Feelings inside me, rise from my Soul,
Love beyond space and time can never end.

Growing old alone is cold, my friend.

I breathe poems for you out of thin air,
From impossible dreams, come impossible words.

Whose arms are holding you now?

If I truly love you,
I will smile at finding a memory,
Made out of diamonds and gold.

NAUL(나얼) _ Memory Of The Wind(바람기억) MV
https://youtu.be/f5ShDNOqq1E
Scan this with a smartphone app that reads QR Codes.

Ronald J Chapman

Beyond the Bounds of Time

MEMORIES UNRAVELING

Many decades past,
Years older,
Life colder,

Oceans apart,
Unable to feel your beating heart,

Memories strung together, unraveling,
Keep seeing your outline in my visions,
Difficulty remembering our passion,

Hard rainy night,
Thundering memories,
Drunk! Seeing our dreams floating away,
In a green bottle of soju,

Still hearing your laugh,
Visions of your smile in flashes of lightning,
There is no need to be sad,

Still seeing visions of your bright smile,
Every morning in every glowing sunrise.

Song for a stormy night
https://youtu.be/YHJTD6ZMNFk
Scan this with a smartphone app that reads QR Codes.

Ronald J Chapman

MISTY RAIN

Your view is vanishing from my memories,
Like walking away in a misty rain,
On this day of tears,

How can I let this love go?
Let love, fly away,
Carried by storm clouds,

Your sunshine left,
Burning in my heart,
I can't forget your bright smile,

You were my blue sky,
Why do I continue to,
Look for you every day?

When I look up,
I see nothing but gray,
Black clouds hiding your bright smile,
Your beautiful dark eyes,

To remember you,
Sends me to a rainy place,
A place of misty tears and gray skies,

Praying for you to return to me someday.

Beyond the Bounds of Time

Ben (벤) Misty Road (Moonlight Drawn By Clouds OST Part 4)
https://youtu.be/-2eyEqaKcDs
Scan this with a smartphone app that reads QR Codes.

Beyond the Bounds of Time

MOONLIGHT

My love for you will never disappear,
As long as the moon hangs in the night sky,

Each full moon,
Reminds me of you,

Dancing on a white sandy beach,
Beneath, the shining spring moon,

With your shiny black hair,
Brushed by a warm ocean breeze,

An Angel in white,
Trying to catch each wave,
With your bare feet,

In this mortal world,
You're the Angel I've waited for a thousand years,

To see dancing in the moonlight.

Beige - I miss you Moonlight Drawn By Clouds OST
https://youtu.be/0MJ4tNyiYaM
Scan this with a smartphone app that reads QR Codes.

Ronald J Chapman

MY DREAM

Time has been standing still,
While I still look for you,
With the coming of a Far Eastern sun,

So much time without you,
My heart stopped beating,
So very long ago,

Looking at you sleeping,

In your dreams;

Are you looking at me?
There is me!
Standing by your side,

It's not easy for me gasping,
Looking at a gorgeous ghost,

But, only a dream,

My final destiny no longer matters,
My heart is empty without you here,

Holding out my empty hand,
Wishing you'd grab on,
And take me back home,

Back home to my dream.

Davichi - A Goose's Dream LIVE [eng sub+kara roman]
https://youtu.be/jMmt1j3KGEA
Scan this with a smartphone app that reads QR Codes.

Beyond the Bounds of Time

NEW DAY'S BREEZE

Ooh, love!
Faith, endurance, and hope,
Cool breeze,
Barley dancing in the fields,

Life is a warm rain falling from a gray sky,

Love is a drizzly rain.
Warm, stormy sunsets hide Heaven's stars,
Why does the sky cry?
Where is the big blue sky?

The warm rain,
Loves, the roof of a small house,
The moon laughs like a haunting memory,

All flowers love bright sunny sunrises.

Love is carried on a new day's breeze.
Love is coffee brewing, banana bread baking,
Love is a bowl of rice and kisses.

[ENG SUB] Apink - Brand New Days MV
https://youtu.be/uGTJsYEetOE
Scan this with a smartphone app that reads QR Codes.

Ronald J Chapman

Beyond the Bounds of Time

NORTH

South of the black clouds,
My Soul flies,
My heart lives.

South of gray clouds,
I walk the streets of Freedom!

Beautiful Han River,
Carries my Spirit,

Memories of dark clouds linger,
Such a black life I had, living under storm clouds,

My wish is, for the dark clouds to vanish,
I want to live under the blue skies of Freedom!
In the place, I was born.

[Official] ONE DREAM ONE KOREA (자막)
https://youtu.be/m4SWTOxwXFs
Scan this with a smartphone app that reads QR Codes.

Ronald J Chapman

Beyond the Bounds of Time

ON RAINY DAYS

On rainy days, you're my umbrella.
On rainy days, you're my sunshine!
On rainy days, you make me smile;

Just as my confidence, becomes cold,
And my hair is soaked,
But still, your smile warms my Soul.

My Soul on fire,
Burning with desire,

Memories of you and I,
Sharing a special umbrella,
On a rainy day.

Patiently waiting,
For a rainbow to appear…

The Classic [Korean Movie] - Rain/Special Umbrella
https://youtu.be/tPl580FPCqk
Scan this with a smartphone app that reads QR Codes.

Ronald J Chapman

Beyond the Bounds of Time

OUR BEAUTIFUL NIGHT LOVE

My Lady Star Shine!
My Angel, your Halo, shines bright!

I long for you every beautiful night,
Your face reminds me of bright sunshine,
Together, we fly high on wings of love,

Oh! my love Star Shine,
Such a beautiful night,
My Bright sky,
My perfect dream,

Your lips are cherry sweet,
You warm me on these cold autumn nights,
Oh! my gorgeous Star Shine,

You are my princess,
My beautiful lover in my dreams,

I can never look at another,
Your starry eyes have trapped my Soul,

You are my love for eternity,

I love you, my Star Shine.

Beyond the Bounds of Time

Vietsub | You Are My Angel - Loretta Chow [Video Lyrics]
https://youtu.be/S9Xr5ccdzF8
Scan this with a smartphone app that reads QR Codes.

Beyond the Bounds of Time

OUR BRIGHT GOLDEN LOVE

My Sky!
My love, my bright golden sunrise,
You make my Soul rise,

Together, we can do anything,

A new day,
Blue silver clouds,
My bright golden yellow sunshine,

I wish I could fly high into your arms,
Flying above, oceans blue,
Flying above an Eastern sea,

I love dark haired Angels,

Oh! darling Sky,
Please send me a miracle,
I want to fly home,

Into your, beautiful Cherry Blossoms on a spring day,
My Princess Sky, the Angel in my dreams,
I wish to walk with you under the spring skies of Seoul,

God! Please send me a miracle,

My destiny is in front of me,
My beautiful dark haired princess is waiting for me.

Beyond the Bounds of Time

Because of You - Baek Ji Young [Hyde, Jekyll, Me OST Part 2]
https://youtu.be/emykUtSQ1TM
Scan this with a smartphone app that reads QR Codes.

Beyond the Bounds of Time

PAINTED SUNRISE

Cold,
Sitting at the table,
Drinking coffee bitters,
To warm my Soul.

Looking out the window,
Through blinds of tall pine trees,

Unable to see your wandering Soul,
Unable to see your blooming heart,
Unable to touch a dream,
Carried by a warm breeze Far from the East.

A flickering candle,

The scent of cherry blossoms,
Piercing the darkness,

A golden flame rises,

Golden skies,
Whites, pinks, and blues,
Floating high above the pines,

Embracing me with warmth,
Warm memories of loving you,

Painting a waking dream at sunrise,
Remembering you.

Ronald J Chapman

Beyond the Bounds of Time

Painter of the wind- Line of sight
https://youtu.be/K98WSkl4rYc
Scan this with a smartphone app that reads QR Codes.

Beyond the Bounds of Time

PASSING SOULS

On our paths that are given to us by fate,
As our Souls move through time eagerly,

No one looks at each other anymore,
Living in our worlds,
Souls simply drifting away,

Looked up for a moment,

Saw her passing,
Walking away,
Covered in a white dress,

Walking towards forever,
Still a stranger,
She's leaving,

Each step she takes,
Leaves me with heartache,

Where are you going?
Come back to me again.

가면 (Mask) OST Part.1 - 린 (LYN) - 단 하루 (One Day)
https://youtu.be/zQNgs_VIoF0
Scan this with a smartphone app that reads QR Codes.

Ronald J Chapman

Beyond the Bounds of Time

RAINY DAYS

It's been raining these spring days incessantly,
No sunrise for so long,

My yearning heart rises each day.

A cold breeze whispers your name.

The day ascends on a great bluebird's wing.

Your sweet voice calms me,
That I carry into the twilight of rain beams,
And hold next to my ear.

You fill me with hope.
Your words dry my wet tears,

As my hand touches my neck,
It reminds me of your warm sunshine.

In the hushed day, I listen for the last drop of rain.

Ailee - Rainy Days [English subs + Romanization + Hangul]
https://youtu.be/y6wWMWYIxA4
Scan this with a smartphone app that reads QR Codes.

Ronald J Chapman

Beyond the Bounds of Time

RED TULIP

Why does the red tulip float?
Why does the flower shine through the window?
The warm breeze shrinks the breathtaking green.
Can't smell a flower, through a cold window.

Springs grow like warm breezes.
Courage, awakening, and blushing in the springtime,
All blossoms show strong, blooming red flowers.

God, such brilliance!

Never smell a tulip through a closed door,

Flower calmly grow like cotton clouds floating in a blue sky,
The sun paints red tulips, with an artistic brush,
Red flowers shake like misty sunrises.

Flowering warmly,
The small life calmly desires the clouds.
And reaches for the sky,
Blushing, like a shy girl.

Red Tulip Bloom, Spring April 14, 2016
https://youtu.be/da-uZZl7C4M
Scan this with a smartphone app that reads QR Codes.

Ronald J Chapman

Beyond the Bounds of Time

RETURNING TO ME

Many times,
You return to me in my midnight dreams,

Follows such bright happiness,
Makes me forget the lonely times,
Living here in this lonesome place,

Returning your warm heart,
Every black night,

I know, I'm foolish waiting,
With hopes and tears falling,
For your return, with heart-broken dreams,

My tears have slowed,
But my heart still aches for you,

I miss your touch,
I miss your hugs,
I miss your love,

How can I ever forget my past,
With you leaving me,
Every bright morning?

Hwajung OST Part.3] Dreaming Dream Yesung (Super Junior)
https://youtu.be/ETRqZSH2gkw
Scan this with a smartphone app that reads QR Codes.

Ronald J Chapman

Beyond the Bounds of Time

SEARCHING

Why do I choose to live without you?
Is that what I truly want?
The pain of an empty heart.

I search and search,
But can't find your touch,
Maybe you don't exist?

You are my true love,
The lover in my dreams,
Please tell me how to find you.

'How Can I Love You' (Descendants Of The Sun OST Part 10)
https://youtu.be/vzUYruNLfBQ
Scan this with a smartphone app that reads QR Codes.

Ronald J Chapman

Beyond the Bounds of Time

TAKE A CHANCE

You and I crossed paths,
For the first time in my dreams.

I've waited so very long,
To cross an endless ocean of time.

Rising into the sky
Above the walls of impossibility,
Not knowing if you truly exist.

No longer feeling alone.

I take a chance,
This fantasy becomes a beautiful story,
My dreams become real.

I look for you,
Waiting for me,
Standing, in the gardens of reality.

Hyun Bin - That Man (Secret Garden OST) [ENGSUB
https://youtu.be/cBSfwZ44zCM
Scan this with a smartphone app that reads QR Codes.

Ronald J Chapman

Beyond the Bounds of Time

TEMPTATION BOUNDS ME

Because of you,
You're standing in front of me,
Tempting me with bright and boundless dreams,

Wishing to spend a lifetime with you,
Temptation bounds me, like a red thread,
Tightening between our hearts,
But unable to say goodbye to this heartbroken life,

I know my head lays on your chest, in some far off time,
Listening to your strong heart calling out to me,
Come closer, in never ending dreams,

I keep looking for your Soul,
Behind your dark brown eyes,
Seeing only myself looking back at me from distant times,

Boundless dreams of an impossible life,
Rescuing me from a sorrowful Soul,
Calling out to me, come back home.

IU - You and I MV [english subs + romanization + hangul]
https://youtu.be/Yjv_T2KA8iQ
Scan this with a smartphone app that reads QR Codes.

Ronald J Chapman

Beyond the Bounds of Time

THE MORNING CALLS TO ME

Believe calmly like a sunny sky,
Wisdom is painting a full moon,
Hope is a new dawn,

Sunbeams bounce off a wavy pond,
Pure fresh breezes bring beautiful desires,
Morning mists float low above the grass,

The warm mist vanishes and brings the bright blue sky,

A charming wind kisses my cheek,
Beautiful skies,
Quickly bring a good day,

Wow, new strength!

A Yeon Baek (Morning of canon (You are my destiny)
https://youtu.be/S95WH_VcIgE
Scan this with a smartphone app that reads QR Codes.

Ronald J Chapman

Beyond the Bounds of Time

TREASURE THE MOMENT

A glimpse of love, from your dark eyes,
Tells me to look at your beautiful smile,
Trying to hold your eyes,

Wishing my dreams come true,
I treasure the moment I met you,

While distance and time separate our Souls,
The larger the emptiness in my heart grows,
Do you know how much I love you?

I always remember times past,
Holding you in my arms,
Kissing your sweet red lips,

On the day you left,
Wishing to meet you again in Heaven or on earth,
Cherishing that day I met you,

So much time has passed...

GUMMY You Are My Everything Descendants of the Sun
https://youtu.be/_8xpk9HFTxc
Scan this with a smartphone app that reads QR Codes.

Ronald J Chapman

Beyond the Bounds of Time

UNFORGETTABLE

Across the vast oceans of space and time,
In a dream of my home,
From so very long ago.

Unforgettable memories flash before my Soul,
Afraid, many times thinking,
I will forget you.

Still, with eyes wide open,
I see you in the Eastern sky at dawn,
Unable to forget a dream.

Memories of you,
Like vivid paintings,
Of cherry blossoms floating on a silver mirrored pond,

Looking at the paintings,
Unable to dry the tears,

Still,

I endure this life because of you,
An unforgettable dream.

I will be right here waiting for you lyrics
https://youtu.be/79jdoDC4f0E
Scan this with a smartphone app that reads QR Codes.

Ronald J Chapman

Beyond the Bounds of Time

WAITING FOR YOU LOVE

A long time to wait,
A long journey to travel,
A long time waiting to touch you, love,

Waiting so long my love,
Can not find the path to your heart,

Morning light, gentle breeze,
Carrying your scent of spring cherry blossom trees,
The morning dew kissing my cheek,
Memories of you.

Hastily, eagerly chasing after, morning shadows,
Wishing to catch a glimpse of you in the morning mist,

Still unable to find,
A clear path to your heart,
To my destiny,

Unable to surrender,
Unable to find the courage,
To travel the long journey,

To touch your heart,
To hold you in my arms.

Beyond the Bounds of Time

The Princess' Man ~ I Will Wait (eng/rom sub)
https://youtu.be/iHf37RNz2KU
Scan this with a smartphone app that reads QR Codes.

Ronald J Chapman

Beyond the Bounds of Time

WATCHING A MIRACLE

When Luna and Venus dance,
Together at dawn,

You and I are looking at a miracle,
From half a world apart,

Before the sun says goodnight,
To Luna and Venus,
Before the stars are covered with a blanket of blue,

Before the sun says goodnight to a miracle,
Before the stars shine brightly over you,
It's time for you and me to look and see,

Our miracle,
Our dream,

As the sun says goodnight to a miracle,
My Soul and the stars will guard you, as you dream,
From half a world away,

Waiting to see you and me dancing at dawn,
Looking at each other's miracle.

Frencheska Farr - Inside My Heart [Moon Embracing The Sun]
https://youtu.be/Ei2Xch5D8RM
Scan this with a smartphone app that reads QR Codes.

WHAT CAN I DO?

Oh! my Love, my Love!
Oh! Angel Love, Angel Love!
I must confess,

Love, how can I send my heart to you?
Love you will never see,
For we have been born decades apart,
A great sea and ocean of time separate our Souls,

I still believe (still, believe),
Friendship! is possible,
Give me a sign,
Dance with me Love in my dreams one more time!

Oh! my Love, my Love!
Oh! you, beautiful you!
What can I do?

Don't you know that you're beautiful!
And I love looking at your image guarding my Soul.
Don't you know if it was possible,
I would travel back in time just to hold you,

Oh! my Love, my Love!
Oh! will, will I ever see you?
Do you miss me too?

Life is not fair,
Oh!, will! Will our dreams come true?

Oh! my Love, my Love!
What can I do?

Beyond the Bounds of Time

Eleven Tells Clara About Rose It's A Love Story
https://youtu.be/0fiwMH3ThJs
Scan this with a smartphone app that reads QR Codes.

[MV] Jung Dongha _ Destiny Sonata (You are my destiny OST
https://youtu.be/0pQCjh_paUU
Scan this with a smartphone app that reads QR Codes.

END NOTES

1 "Korea is a historical state in Northeast Asia, since 1945 divided into two distinct sovereign states: North Korea and South Korea. Located on the Korean Peninsula, Korea is bordered by China to the northwest and Russia to the northeast."- From Wikipedia, the free encyclopedia,
https://en.wikipedia.org/wiki/Korea
(accessed December 8, 2016).

2 "The Kingdom of Joseon was a Korean kingdom founded by Yi Seonggye that lasted for approximately five centuries, from July 1392 to October 1897. It was officially renamed the Korean Empire in October 1897" - From Wikipedia, the free encyclopedia, https://en.wikipedia.org/wiki/Joseon (accessed December 8, 2016).

3 "Soju is a distilled beverage containing ethanol and water. It is usually consumed neat. Considered "Korea's most popular alcoholic beverage" in 2014." - From Wikipedia, the free encyclopedia, https://en.wikipedia.org/wiki/Soju (accessed December 8, 2016).

4 "Seoul, the capital of South Korea, is a huge metropolis where modern skyscrapers, high-tech subways and pop culture meet Buddhist temples, palaces and street markets." - From Wikipedia, the free encyclopedia,
https://en.wikipedia.org/wiki/Seoul
(accessed December 8, 2016).

5 "A kumiho (gumiho) (Korean pronunciation: [kumiho]; Hangul: 구미호; Hanja: 九尾狐, literally "nine-tailed fox") is a creature that appears in the oral tales and legends of Korea." - From Wikipedia, the free encyclopedia,
https://en.wikipedia.org/wiki/Kumiho
(accessed December 8, 2016).

6 "The haegeum (Hangul: 해금) is a traditional Korean string instrument, resembling a fiddle. It is popularly known as kkangkkangi. It has a rodlike neck, a hollow wooden soundbox, and two silk strings, and is held vertically on the knee of the performer and played with a bow." - From Wikipedia, the free encyclopedia, https://en.wikipedia.org/wiki/Haegeum
(accessed December 8, 2016).

www.ingramcontent.com/pod-product-compliance
Lightning Source LLC
Chambersburg PA
CBHW021440170526
45164CB00001B/321